Tenderly,
Amy

Sketches of Home

SKETCHES
OF HOME

SUZANNE CLARK

Canon Press

MOSCOW, IDAHO

Suzanne Clark, *Sketches of Home*

© 1998 by Suzanne Clark
Published by Canon Press, P.O. Box 8741, Moscow, ID 83843
800-488-2034

01 00 99 98 9 8 7 6 5 4 3 2 1

Cover art by Al Clark
Cover arrangement by Paige Atwood Design, Moscow, ID

Printed in the United States of America.

ISBN: 1-885767-35-8

For my mother,
Mary Lee Hester

Sketches of Home

Author's Note

I wrote a poem when I was six called "The Secret Stream."
It was my first such effort, a childish, artless bit of verse—
"I love my little flowing stream/It seems as though it's just
a dream"—but years later, as I was walking along the Vir-
ginia Creeper Trail with my family diminishing in the dis-
tance and the yellow curling leaves of autumn blowing around
my head, I thought of that stream and was given to know
its meaning. The stream was a prayer, a hunger of heart—
"When I look up in the sky so blue/Everything I wish comes
true"—a way for me to shut my eyes, as poet Patrick
Kavanagh said, to see my way to heaven.

God had planted in me a secret stream to be the source
of poems to help me see. Through my childhood years and
on into adulthood I wrote for pleasure and insight. So it
was when I married that I began to keep a journal of stab-
bing moments that would, twenty years later, become *Sketches
of Home.* "What earthly sweetness remaineth unmixed with
grief?" wrote St. John of Damascus. Sweetness and grief
mingle in the song of life.

I write as a way of suspending my longings, of grant-
ing immortality to the visions that crack the clay mold of
daily existence. Once I was sitting in church and happened

to notice four-year-old Allison Jones smiling at me. For an instant I saw the love of heaven turned fully upon me, and I had to turn my head to hide my tears. Wherever I go I see burning bushes, objects on fire: the needle I keep in the hem of my bathroom curtain for taking out a splinter or sewing on a last-minute button. Fragments of pottery and porcelain I dig up every spring when I plant my garden. Ivy that twists through the cinderblocks in my basement. Each of these whispers, "What is my meaning?" When I look closely, I learn my own story, a story shadowed forth by the all-wise God. To write is to cherish, even in the presence of pain.

May you, my reader, cherish the drowsy bee and skipping boy. As a famous architect once said, "God is in the details," even down to the inscription on the horses' harness bells pictured on the great and terrible day of His coming: "Holiness unto the Lord."

I

THRESHOLD

The Richest Woman

I have been married a week. I call myself Rebekah, after the Old Testament bride chosen for Isaac. I've been thinking of your body—the tent of you enclosing me, the secrecy of skin. On a skin of water we glided at Fall Creek Falls. Between paddle strokes the pauses were silver, and our eyes could not unlock. Why should we want words?

I am Sheba, the richest woman. Here, take my pearls. I will have your spices.

At White's Mill the water sang everywhere, in columns and streams and falls. It was architecture and orchestra. We saw 30,000 trout (said the sign), some speckled, some gold in pools flashing. You bought me flour for bread. We will take this communion all of our lives until Love Most High consumes our separate dust.

Raining

You're sleeping before graveyard, and I'm alone with the rain, long and slow like time. I put my book down, to listen.

This is the last rain of the warm season, according to Ida Belle and Hattie who were out on their porch when I was shaking my dustmop this afternoon. They know all sorts of mysteries: the dangers of dog days, secrets of having a girl child, tricks for rooting flowers. Behind the rain I hear frozen trees scraping against the house, and the stomp of your snow-packed boots on the mat.

By winter we will love each other more but I don't see how. In one brief summer I have forgotten what it was like to be single. Why do you sleep so long?

Maybe we can go camping in the mountains soon, before the first frost. In the dark tent we'll cling and make a knot against the vastness.

The deep says we are eternal. I cannot take it in. Only the rain unbroken teaches me just now that we will be lovers forever.

A Neglected Virtue

There is much to be pondered Monday nights when taking out the weekly trash. Tonight with the honeysuckle gone and the air husky with dew and the apples fallen, I see I have also turned a season since love was new and I expected Al to lug garbage. How I'd despaired when neither polite appeals nor nagging threats inspired him to rise from his TV show. The books on marriage I had read made it clear Al should take out the trash. Something was definitely wrong.

But now it is September and I am wiser, you see, hauling the garbage cans one by one across the long, black yard. Certainly there are other virtues besides the sense of duty. What about the sense of play? Who but Al would stage a water fight at midnight and accidently lock us out of house and home, wearing next to nothing? Who but Al would whisk me off in the dark to a secret destination which turned out to be the Appalachian Fair—at closing. Who but Al would spend an hour making a surprise breakfast—a scrambled egg clown with raisin eyes and mouth—and leave the kitchen a colossal mess for me clean up. Who but Al would call from work disguising his voice as a Vietnamese immigrant or loan collection agent.

You can have your tame and tidy textbook spouse. I will have Al.

Mothmaker

Al presented me with a moth tonight, a perfectly preserved Polyphemus.

Engrossed in my typing, I was startled to see it out of the corner of my eye, pinned to the bulletin board. After my initial horror I began to inspect it, but not without qualms, sensing that I who was made to sleep through the dark am trespassing by looking too long on this burlesque creature with feather headdress and markings designed for the night. Yet I am fascinated with the macabre beauty of this moth that could pass for a bird, this inversion of a butterfly.

It is cut out for moonlight that silver might catch its fringe. It is painted to blend with shades of dusk through dawn, its tawny wings marked with mauve, indigo, and dashes of yellow. If not I then who was meant to observe the moth lighting on a cold leaf or circling in a black sky or thumping against wet roses closed? It would be Someone who sees the dark as light and who applauds on high the lone vaudevillian.

A Forever Farmhouse

I have come to see at this bend of my life I am still on the road to Grandma's—a dirt road buried under asphalt leading to a white frame farmhouse deep in the Alabama countryside. When I get there, hurrying to the front porch with my sister Leslie or friend Betty or whomever I've brought, we all get swept up (including suitcases) in the hugest hug we ever had. Behind us in the doorway is Grandpa grinning.

All our Southern kin view our coming as a grand event. Down they pour off the knob my mother calls Mt. Baldie and in from Hartselle and Huntsville and as far as Birmingham. Uncles, aunts, cousins, neighbors sit together in the living room with the woodstove throwing out waves of delicious heat while kids play around our feet and laughter rises. The door squeaks open and shuts again and again as visitors come and go. Finally, someone props it in place with an ancient, hairless coconut that always reminded me of a monkey. Through the window I look at the people on the porch and the cars lined up in the yard and the brown road I pretend is a river snaking through unknown wilds, but the voices bring me back. Sometimes there is sadness as we hear Uncle John's gone to Summerford Rest Home or little Wayne has cancer. It is an eternal scene: it seems I

have forever known this room, these faces, Grandpa add-
ing logs, the sense of belonging.

The true monument at Grandma's is the table. There
is food for everyone from first shift to last as people come
and go: Aunt Mattie Lou, Dannie Rex, HC, Francine. We
set Grandma's table with a soft lace cloth, with the beauti-
ful gold-rimmed anniversary china given by the family to
celebrate fifty years of marriage to Grandpa, known also as
"the Chief." Grandpa had a little wire that poked through
his scalp from brain surgery he'd had in the Forties, and a
stub for an index finger where a machine once caught his
hand; he disliked wearing teeth and loved drawing Nettie
into quarrels staged for the benefit of company. He fixed
all broken things, sat us on his tractor, let me kiss his
weathery cheek, and sang old-time songs for joy. All foods
came first to him: steaming bowls and platters of squash
and okra, beans, roast pork, cornbread, potatoes, piccalilli.

Behind us the top of the freezer is crowded with sweet
wonders performed by aunts: bulgy apple pies, banana pudding
with meringue sweating amber droplets, rich chocolate cakes,
fresh strawberries, nut bread. I can remember as a child
watching big-boned Uncle William prop food onto his fork
with a shiny thumb, or Grandpa at breakfast mix butter
with molasses to spread like paste on his biscuit. Or Grandma,
stirring her coffee while staring deep into nowhere I could
see. After supper we always scrape the plates and Grandpa
bangs the screen door three times to summon Jabbo, his
dog and loyal friend, to the banquet.

One of the greatest pleasures at Grandma's is to step
out the back door from that noisy, relaxed house of dishes
and kids and too much heat into the sudden quiet of the

yard and fields beyond. Above me are chips of light, a pale moon, and before me as shadows are the barn, well, wood-pile, woods. A thousand memories flash through my mind: the time Cousin Edward Crow, sunbrown and barefoot, pulled a watermelon off the vine, broke it open, and my sisters and I sat on the grass and ate the hot, sugary fruit which later sent us one by one to the outhouse where a chicken was spotted looking up at me through the hole and had to be asked to leave. Or the time a tornado watch drove us out into lashing rain to Grandpa's storm pit. We sat on benches in the concrete room of spiders while Grandpa's ear beheld the Scanner's crackly voice and I re-cited the Twenty-third Psalm in flickering lamplight, waiting with terror for the roar of cows and houses devoured by wind.

There are other places: six crumbling tombstones in a neighbor's field, the secret creek I discovered in the weeds, a whispering cornfield where I lost myself to think up po-ems, a cow pasture that turns gold each fall. All these are part of me, strands of a root from which I spring.

On my last visit to Grandma's I brought my new hus-band, Al. In the rainy dark we watched the highway out of Falkville for the train crossing where we turn to get on the road that rises and falls from Piney Grove Church clear to Grandma's driveway. We pulled up, grabbed our stuff, headed for the porch with Jabbo at our heels, got pulled in by Grandma's hugs as Grandpa came out grinning. Later, af-ter talking over oven-warm cornbread and green beans with ham, Al and I lay under homemade quilts and listened to the rain tapping on tin. I told him I was pleased to share the quilts with him, the biscuits and Aunt Mattie Lou and

the storm cellar and creek. Someday, if the Lord wills, we will have children scrambling underfoot, exploring the barn with its hidden kittens and receiving sugar, eternal sugar from Grandma.

Impossible Child

Sublime. This is my word for the incarnation taking place.
I am regal, sobered with the knowledge that deep in my
body is a microscopic child, sacred and beloved. I float.

Obstetrics

Tomorrow they will tell me what I know.
After tools and taps they will talk in facts
of mystery, of the flame in so dark
a place you want to look and see God
shaping the hands and face.
They will call it by other names
but I will be hearing
blood and bones sliding in place
to music steep as stars.

I am in a dream
while the doctor feels clay
and schedules birth on a chart unreal.
As the earthen womb sings,
making its pearl,
I allow everything:
quake of birth that will leave the poem
of dust in my mouth.

Weeks and months pass. The queen turns into an elephant. There are new mysteries. How to eat crackers in church without anyone noticing because the "baby" has to eat. How to get past people in a crowd without knocking them over with your belly. How to fall asleep on your back when you are a stomach person. How to put out heartburn. How to keep from crying when your husband blinks the wrong way.

I lie in bed on my back for hours studying my bald mountain of a stomach. Who are you? Under that tight skin lives an impossible child whose legs and arms both flutter and punch, whose ears absorb every word I speak, and whose heart, I am sure, senses my two-edged love, fierce and tender.

I have a friend whose baby was born at 21-weeks' gestation. He died in her hand. I attended the funeral and wrote an elegy to commemorate her child born out of time:

Treasure

"I shall go to him, but he shall not return to me"
(2 Samuel 12:23)

You held him, a glistening pearl,
named in the bends of birth
with a name true as gold,
a prophet's name whispered
to him like a promise.
(Little shivering fish
too small to cry
or see you with the face of water
holding his image like a coin,
praying while he flickers in your hand

then fades.)
His soft clothes hurt you now,
his wrong room glares.
His silence is a sea but you
will say the name
that burns like salt on your lips
but also heals
and is the earnest of him
who lines your heart
with nacre.

As Christmas nears I am drawn to Mary: Mary holding
her hands on her belly to feel the spasms made by her baby's
hiccups; Mary imagining the face of God. What paradox.
What double awe. Not only was she struck with the won-
der every mother feels in bearing a child, but she also mar-
velled that the child was divine: earthly but unearthly; in-
fantile, yet older than time and timeless. I picture the hard-
ships she suffered, the difficulty of giving birth in a barn.

Joseph at My Side

You caught him
a watery weight
and laid him raw
against me.

My lips were parched,
you gave drink, your hands
still streaked and trembling.

You took the afterbirth away
then sheltered us
with your shoulders.

Our words were hushed,
like dove's words:

Joseph, you are strong like a mountain.

Sleep now. Let me take my God-boy.

Did she know the terrible things her Son would suffer? Was her motherly joy mingled with dread?

I cannot help thinking of the forgotten babies who will not see their mothers' face, not ever. In each case, the quiet golden world of the unborn is punctured with an instrument that suctions out the flowering little body until it is shredded into a ghastly soup of blood and bone. For these children and for their mothers who betrayed them, I weep, even as I carry my cherished one.

McFetus

The dirt in people's cars is quite like hell:
ketchup sacs, french fry stubs and Bud-
weisers crunched, buds & stubs & wrappers
translucent—eyes loose
and coins, fishhooks,
fontanel.

Lately I have had a profound sense of the certainty that I will actually see Jesus Christ before too terribly long. "I shall be fully satisfied when I awake beholding your form," wrote David the psalmist. What a breathtaking thought: One day I will open my eyes from death and behold the altogether lovely, the dear and holy face of Jesus. I will say what the convert in *The Screwtape Letters* said when he awakened to eternal life: "So, it was *you* all the time."

Homecoming

How can I tell you what I feel coming home? All at once
the door opens and out come liquid violins and you are
kissing me and taking Katy, now seating me queen-like with
vases of roses on either side. The whole house shimmers.
We tour Katy's room of balloons. See if she likes her crib,
I say. How can she be so small? She makes my heart ache.
Are the pictures back? Is there mail? My body hurts. Hold
me. Inside is dark with the light.

Now to the table where we eat Chinese food by candle-
light with Katy parked beside us in her ruffle-skirted
bassinette. We are in awe of our roselet. She has made us
new.

The Accident

Today you are ten months old. We celebrated by visiting neighborhood cats: Charlotte, thick with fur and years, the playful black cat on Georgia Avenue who attacked your stroller; the grey kitten across the street. What splendid friends. There is also a horse named Ivory on our beat. Sometimes I give him an apple and you crow.

But death is never far from innocent things. A cat was hit by a car the other night in front of our house. It was in the street still alive. My first instinct was to run inside and hide. But I forced myself to go see about it. Dear dying creature with a breath faint as the glimmer of a star. I gather her up, leaving a small circle of blood on the pavement. I place her gently on the side of the road and mourn. The small rhythm stops. Cars flow past and I leave her to stiffen in the dark. Inside my house of lights, Katy will comfort me. Her small body in my arms will fill a hole in a universe of many losses.

\mathscr{C}hristmas \mathscr{P}arade

This morning you pulled yourself up for the first time. I was on hand to witness the historic moment. You stood up nonchalantly in your crib looking at me.

Later that evening we went to a parade, the annual Christmas one. As we were there in the crowd, our faces cold in the night air, and as the high school band marched crisply by, blaring "Angels We Have Heard on High," my heart swelled with emotion and I held you hard. My baby, little piece of me.

You were dazzled by flashing fire trucks and glittering baton twirlers, by Army tanks, church floats, beauty queens and Boy Scouts. All around us were faces of townfolk: children wide-eyed and fathers looking for Santa; an old couple behind us with no teeth smiling at you as you flapped your arms and gurgled. I laughed mercilessly (and silently) at myself for the tears I couldn't fight. How many semesters I had taught poetry students not to be taken in by sentimentality—the old oaken bucket, mother's rocking chair—and here was I, the worst offender, crying at the wholesomeness of this old-fashioned parade with its rousing band and season's greetings under the ancient stars—and my little daughter in my arms drinking in a river of sequined light. I

wanted to cry at the goodness of God who has poured himself into every spellbound child and joyful carol. Bless him.

*C*rocuses

Today I went looking for crocuses. Foolish idea, what with the ground still brittle from the coldest spell of the year. The sharp air cleared my head of grammatical rubble I would supposedly be assembling for my students tomorrow. Perhaps I would find agreement of a deeper sort under winter's glaze.

Has it been a year, I ask, examining the forsythia's slim boughs for buds. Katy came and then life was spent entirely for others—the laundry, cooking, dishes, my ragdoll body; Al holding me when I was drowning in a sea of insomnia and tears.

Look. Buds. I touch the row of embryonic knobs along the slender branch. A wren sings its trills. I chirp back. Imagine that, buds already. I inspect the herb garden, wood pile, the limp rhododendron, and lift my face to the cold sun. In my mind's light I see someone moving back in, smiling, arms weighted down with suitcases that hold stars, the deep woods, a fast stream, daisies. She sets the bags down, is off again. I watch her weaving through a meadow, holding Katy's tiny hand. The two of us grow smaller and smaller, arms swinging against a blue sweep of sky. There will be a picnic, laughter, small treasures in the grass.

Welcome home, spring.

Tell Me Why

As I braid your hair, standing you close so that the backs of your legs press against my knees, I sense mystery. Gold into gold and gold again, and the secret takes shape in my hands: simply that you are my child, branch of my vine. There, that's done. Now the other.

Perhaps it is the sense of ritual, of mothers through endless ages braiding the hair of daughters, that stirs this awareness of our connection. I do not know, but I am reassured. Lately it has seemed you are *not* my child, rising up against me, calling yourself "bigger," refusing bedtime stories, wiping off kisses. Now look in the mirror and see the neat braids. Go ahead, look really close and see the eyes behind your own—not now, but someday, when you falter to know who you are, when you forget why the ivy twines.

Katy at the Seashore

It was the first time you saw the sea. Daddy plopped you onto the sand and you stood astonished, sky and screaming gulls above, the ocean exploding before you. It was simply too much for one so small to take in, to feel your feet sinking into the floor. Before you knew it you were swept up by Daddy's arms and carried to the ragged ocean edge where water swirled about you and you squealed without ceasing.

Now you are atop a white charger on a flashy carousel. Its jewels and lights throw color recklessly into the night. Its gay circus tune flies far out to sea becoming thunder. Your hands are frozen to the pole, the glee in your face fixed as you go round and round, oblivious to me, waving. All the pomp and circumstance of all history and the age to come is reflected in your small face. The horse was never so honored as tonight.

Stephen's Birth

Stephen, as you lie on a blanket on the floor beside the fire and we are listening to Bach and it is snowing outside; as the logs age quickly and fall to pieces and we are caught in a moment beyond time, I want to tell of a journey taken four months ago.

Every time I look at the photograph of us in the delivery room—our eyes closed, lids swollen, faces pale and dreamlike—I think of survival and yes relief, but also a certain sadness. How terrified you must have been, jolted loose from your cave of water and my heartbeat, then pumped and squeezed roughly along by hard, rubber-like muscles. And then for you to emerge bloody and blue with the cord around your neck, the doctors hurrying to free you, the shock of light, the distress of your body being pulled every which-way. I wanted you on my belly.

For nine hours we labored. None of these crisp professionals nor even my own husband could enter the canyon of dragons. Their medical talk made me sick, textbook words used to describe my condition—but it wasn't me whose pains were tracked like hysteria on their graph, whose IV dripped methodically while my blood writhed. Panicking, I told them I was dying but they didn't believe me,

repeating instead their orders to "do your breathing," an idiot's rhyme I was supposed to chant—"hee-hee-hee-hoo"— as if to ward off the fiery jaws bearing down. The last straw came when the nurse put her face in my face to coach me. "Hee-hee-hee," she said. Grabbing my sick pan, I banged it against the wall and roared, "Get out!" Later, we laughed about this, but at the time it should have been understood there is no power on earth so fierce as a laboring woman crying the ancient cry.

At last it's over. You are safe. I kiss you and leave a tear like a jewel on your cheek. All around us are sounds of business: tinkling of instruments, drone of doctors' voices, rustle of sheets. But you and I are wrapped in a kind of holy peace, as if under a wing. Now they are reaching to take you away. I'm still trembling.

It will be days, no, a lifetime before the sense of awe leaves me, for your birth, my son, is somehow connected to the heart of the universe where pain has presence because of divine decree. Jesus, lamb of God, was torn by wolves of pain as we were, but his was unto death and more terrible because he took our sins upon himself. That was so you could have eternal life. There is meaning in our suffering, for we tasted in some way I cannot explain, the Lord himself. It is so for every child and his mother.

Soft Boy

I love your hands, cloud puffs, pillows. Soft or not, the hands are bossy, going for my hair, nose, ribbon on my blouse—anything they desire the hands grab, to go of course into the mouth with its voracious gums.

There are also your cheeks, soft as dumplings, dimpling when you laugh. I love your laugh, proceeding first from the eyes, then spreading to your mouth in a grin that seems as big as you are—and on to the belly that shakes as you laugh, fat puppy's belly, plush toy, marshmallow boy, my Stephen.

My Bonaparte

Is it not reasonable, Stephen Franklin Clark, to think you will be President? The way you stand at the coffee table, your legs locked, arms stiff with conviction as you pound the table, is distinctly dictatorial. Nor can one help but marvel at the force and authority with which you utter some noble pronouncement: Da da. You fairly spit the words out as if commanding troops or an inattentive father.

There are other telltale signs. When scooting toward your favorite plant or bookshelf you refuse to take no for an answer, indignant that a mere subordinate should take it upon herself to move you elsewhere. And who but a future president would demand, upon entering a room, that each person notice his presence with profuse smiles and waving of hands.

If only you would let me rock you. Perhaps you would soften into an artist or preacher. But even in my arms you are in charge, struggling to stand, to view the world and render it your own with the trumpet-voice of Napoleon.

Sunday School

I hear you in there, little bells, a charm bracelet of voices behind the door. While we Young Marrieds investigate theological aspects of the Jewish exile, you, no doubt, are furiously zigzagging purple across the face of Jesus. Suddenly the bell-voices clang, shattering our exile: "Praise Him, praise Him, all ye little children!" Miss Grace starts another chorus and up go your songs like balloons. I imagine them sailing clean to heaven where everyone shouts, having entered as children.

*C*oma

Mark, Mark, what sleep is this, deeper than our reach? We would wrap you in our arms as Elijah did a child and kiss you all awash with our tears to somehow bring you up out of the watery void.

Sometimes your eyes open; they are little boats floating somewhere, nowhere. You move, and the room is amazed for a moment, but falls back as you stop, stone-like. This falsehood repeats itself a thousand times: the slight flexing of your knee, the hand curling. We call to you and sing and wear purple, your favorite color, but nothing wakes you.

Tonight, in bed, I shut my eyes, and your blanched face surfaces like a mask. Then Katy's face appears and a scene presents itself, painful to contemplate: it is the church nursery where you and she played together for three years, with you not knowing there would, on a certain fall morning, be water all around you and a terrified thrashing and then an absence. I think of you pulling a wooden turtle on wheels and Katy clapping her hands, but what I see is the harm of brightly painted balloons on walls, the danger of flowered curtains.

For now I will think of the turtle, of your dark sleep as hibernation, of Jesus housing you, holding you, and I will try to stop demanding that he let you go.

Hanging Wash

The way I felt about the wash was poetry. Here go hands into a wet clump of clothes, then up fly sheets to be pinned against wind. Socks and bras, shirts, nighties, diapers and towels become a glorious kite while about me run two small children laughing like windchimes and I feel pure as the snow-white sun.

\mathscr{S}pring \mathscr{O}uting

Yesterday we went to the park hilling and flowing with green.
As you ran before me spilling, rising, giggling into the wind,
I felt the whole sweet spring inside me and worshipped the
One who flings out all this joy. Tagging along behind you
children, I perceived the singing trees and grass to be pos-
sessed by more than what Dylan Thomas called a "force
that through the green fuse drives the flower." I must say
it was a Presence.

*B*amboo

All I wanted was an ordinary back yard with a fence around it, some trees and flowers, neatly-trimmed grass, a swingset for the children, and a clothesline. On summer evenings we would sit in lawn chairs watching our children at play and admiring the pleasantness of our well-kept yard.

But you wanted bamboo. The first year I barely noticed the few shaggy shoots you planted on our side of the neighbor's fence. The next year there were more, then more and more, with bamboo springing up everywhere, including, to the neighbor's dismay, her yard.

Thus was I forced into war with your alien plant whose roots race to send up sprouts across the lawn as if they were in China. This spring the shoots are skyscrapers. Entire cities grow overnight. I keep stamping them down, splitting and twisting the splintering poles that spill rainwater. The new sprouts are easily stomped, tender and asparagus-like. My yard looks like a bamboo graveyard. Jagged pipes stick up all over. Leafy, yellowing branches are strewn everywhere. And although with every rain the bamboo advances to new ground (its sights fixed, I am certain, on the territory belonging to the swingset), I do not feel good about the carnage.

It is not as if the bamboo is unsightly, like kudzu or cat's claw. And it must possess a decent soul if so gentle an animal as the panda considers it fit food. Sometimes I am tempted to simply let the bamboo go, transforming our yard into a sea of green curls. You, untamed one, would probably love nothing better. I can see you leading our family on expeditions through labyrinths of stalks, with the children following secret trails in search of their swingset and I hunting the noble lawn chair as a relic from the past.

Mildred

I know a songbird who works in a factory and lives in a Victorian house. Atop oak dressers heavy as elephants, inside ancient teacups and brittle brown books are sunny surprises: a fish for the kitchen, peonies in a pure white vase, earthen pitchers glazed with sunrise, photos of new brides, trinkets in secret drawers for grandchildren. Upstairs and down are ruffles just washed on curtains and pillows and bedspreads. Floors glow, plants gleam, breezes sing through open windows. Nothing in a closet has a wrinkle.

My mother-in-law, Mildred, told me that when she was eight, she watched her mother die raking leaves. Mildred spent the rest of her childhood clinging to an older sister she slept with or waiting after school in the dark kitchen for Papa to come home and light the woodstove. She did not stay sad but wished hard for the world to brighten. At sixteen she married Jeff, years older, handsome and fast. Seven babies followed (one died) and among the black trunks and deep drawers of the house Jeff inherited, sprouted dolls and toy trucks and crayons.

The house is not permitted to age. Today grandchildren crawl, stumble, run through rooms while Mildred sweeps out darkness. No ancestors gather dust; they are opened

routinely to guests and sunlight lest their stern faces mold
in elderly albums. So it is with antique quilts, water-stained
paintings, silver thimbles. All the brief things of a life are
tended like flowers by hands that seem to sing.

Valedictorian

Tonight Debbie will graduate from high school at the head of her class. At five-thirty she will bathe and perfume herself while rehearsing her speech.

She will slip into a dress light as petals and her hair will be soft, on this night of nights, as wind. She will be the loveliest of all the girls in white, for the Lord has given her beauty from ashes. When she was twelve, a rare and viciously aggressive tumor was found in her abdomen. After surgery, her cells were burned and poisoned, poisoned and burned. At home, she was lifted to the table for force-feeding and carried to the couch and bathroom, barely alive, with her arms dangling from her father's as he cradled her off to bed.

The first time I met Debbie was in the spring. She was staying in Memphis for treatment at St. Jude's Hospital. I remember the liquid sun, the cascades of pink and white blooms. At my pastor's request I picked up Debbie and her mother Joanne at their hotel to take them to church. Debbie, in a dress of pastel fluff that made the sick girl look even sicker, was helped to the car by her mother who chatted matter-of-factly while arranging her spindly daughter on the back seat. I drove to church swatting tears while a verse

in Isaiah spoke itself: "It pleased the Lord to bruise him, to put him to grief."

As we pulled up to the church, I was wondering how I would ever be able to accept Debbie's death. Joanne, still talking, scooped her daughter up like a doll and went inside. (I was soon to learn that Joanne always talked her way through pain and fear. She and her husband had been missionaries to native Brazilians for ten years. Joanne had lost a baby three days old in the steamy little compound among strangers. Now she was meeting people at church and making arrangements for Debbie as if nothing were amiss while I hung back trying to compose myself.)

But, as I said, that was long ago. Tonight Debbie will deliver her speech which will, in the white flow of graduates, be soon forgotten as all are dismissed to exchange farewells and discuss futures. Debbie will be among them, conversing brightly, hugging friends, posing for pictures with her family circling her like a wreath. I will watch from the side and smile for Debbie's sake, fiercely forbidding tears when I hear whispered within: "For I am persuaded that neither death, nor life, nor angels, nor principalities, nor powers, nor things present, nor things to come, nor height, nor depth, nor any other creature, shall be able to separate us from the love of God, which is in Christ Jesus our Lord" (Romans 8:38,39).

On High Horses

I sing of words preposterous, of speed lemons and babloons and music to my nose (the smell of coffee). I sing of blood jumping up and down and kicking its feet, the way you once described excitement. I sing of runful and jumpful.

Blessed be your verbs: "Mommy, I drinkdid a glass of water," "I wroot you a letter," "I holded on," "I bees happy." Off you go on high horses, two jesters juggling cockeyed words into my straight and narrow air.

Kix, Trix and Smacks

Do FrootLoops get rotten? you demand to know. It is seven a.m. and you are displaying your usual knack for thinking up brain-twisters while I am trying to do the impossible: in this case read a recipe and butter your toast at the same time—and all on an empty coffeepot. Regrettably, I answer, they do not. On the contrary, these plastic bloops are mummified in a mysterious coating of orange and purple that renders them immutable. I for one am indignant, having been overruled—no, entirely ignored—in the question of toy cereal, to which I am staunchly opposed.

It is all your father's doing, stealing off to the all-night Kroger while I am sleeping sensibly, bringing home economy-sized boxes of Cocoa Puffs or Sugar Pops, and in the morning securing the unbridled adoration of you and your brother. If only you could remember it is *I* who am the Good Person in this story, I who would spare you the multitudinous evils of loony loops and zany flakes. But such hope I know is folly as I observe the awe in your eyes beholding a variety pak of the latest cereal fads left on the table as a present by your ever-loving daddy. May Kix, Trix, Smacks, and Dino Pebbles beset him all the days of his Life.

At Jonesboro, Fourth of July

At Jonesboro they were fiddlin' and flat-footin'. We were sitting high on a hill of neighbors, on blankets damp with dew when John McCutcheon came playing the dulcimer, a harp of water calling in the night to creeks and springs, to forests and hidden log shacks flowing as pine and smoke down the old mountain bearing our spirit. Then the sky flashed and sizzled red and white against black, making our mouths go O.

Softly, John began to sing, drawing us into the melody which spread as a benediction over the hill of us and drifted off toward far-away mountains: "God bless America, land that I love." The trees and streams gathered round our camp and we were crowned that night with light of falling stars.

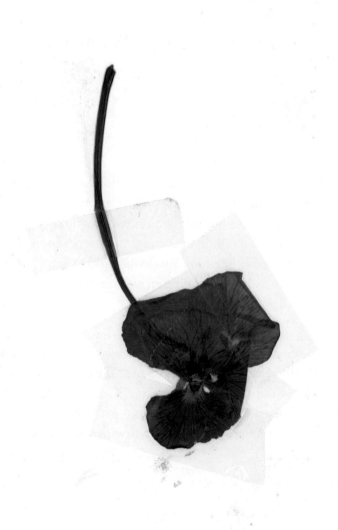

Salad Bowl

In the salad I see glory. Cucumber lenses conduct light. Radishes hold white fire. Lavish petticoats of lettuce conceal mushroom peasants. And what a fracas of green: celery, shallots, peppers, spinach, parsley. But the tomato tells the most, ripe as a heart. I wince when I cut, for it is the most human fruit in all the bowl.

Unwashed Dishes

As I write these words, dust drifts across the floor. Stacks of urgent mail grow tall. The dollhouse curtains stay unmade. Laundry ripens.

I need you to understand that I write because poems do not break. They do not follow a clock. Like us, they breathe the air of hamburgers frying, but it is air charged with eternity. The breakfast dishes would steal my words, my aching words.

The Vine

I was with the vine today, pulling grapes. Each bee left; I feared no sting. The sun lay heavy on me like a hand, and I sensed the summer sinking as if stricken, slumping into a sea of crickets already chanting of darkness and hidden ice.

The vine had been productive, crowded with clusters of grapes filmy blue and fragrant. Some bled when severed. Green or withered ones were discarded. The work made me drowsy, as with wine. I would go in and sleep for awhile, dreaming of the vine and a kingdom.

The Hike

There is no trail in these woods, only the brown river that is the residue of gold burned off the trees. It is steep going: Al holds Stephen's hand and I Katy's as we trudge toward the sky. Who would think of talking in such a lonely place of no birds, for it is rather a time to think deeply as our feet break fallen things. Yet here is Katy chattering without pause, and Stephen reciting his Superfriends. Al glances back; we exchange smiles at the inappropriate joy of our children that springs up in forlorn seasons of mind like dandelions.

2

CORRIDORS

Family Portrait

Here is a photograph of an imaginary family. The mother, with her beautiful silky face, smiles I think sadly, but that impression may be derived from the dream quality of the picture. The father, charming in an Air Force uniform, has a carefree, boyish appearance. The three children are but babies with eyes magical and bright. So little about the father would stay with them: odd things, like hot dog soup and a recording of "The Teddy Bears' Picnic." The only other memory, that of being held, is so dim it might be a wish.

There is no recollection of divorce, but some unforeseen calamity struck causing the carousel to overturn so all the children were thrown out. One remembers sitting for hours in blinding sun on a step overlooking railroad tracks waiting for her mother to come back, not understanding the mother was made to sign papers somewhere far away.

Ages later the father met his daughters at an airport to pick up pieces. He hurried toward them, smiling like a boy. They could not take it in that this their father was standing before them and now was embracing them. But where was his sorrow? The voice that should be breaking off in

the middle of explanations? Over dinner he chatted com-
fortably, asking many questions. The daughter adored him
with his crinkly eyes and gentle manner but was unable to
come out of the dream. She waited for the revelation but it
never came. Just a few simple words—"For the pain I caused
you . . . for my absence"—and she could have traveled back
in time, orbiting past pieces of dreams, landing safely in a
child's room with a father's arms around her and the moon
bright as an angel in the window. But it was not to be.

The father departs; he writes now and then; he stops
writing and fades as dreams do. The daughter will continue
to look at the picture sometimes, but she will not explain
its spell. Even if the father should come to life again, she
will always see a stranger.

\mathscr{A}musement \mathscr{P}ark

We are all bunched up in the back seat of the 1960 Buick LeSabre—Robyn, Leslie, Marilyn, and I. The windows are rolled down, and wind drowns Daddy's words to Mommy as we zoom along the highway. We are all hips and elbows and knees and bubble gum and giggles on this hot Saturday morning—too happy to argue, too excited to think of any trouble—for we, the Hesters, are about to arrive at Glen Echo Amusement Park. The ivy-covered stone gates are nearly in view. Straining my neck over Robyn's shoulder I can almost make out the dizzying wooden peaks of the monstrous roller coaster I refuse to ride despite all bribes and cajoling—unlike my step-sister Marilyn who will march to be first in line, carrying her brown bag with a spare pair of underpants, just in case.

This will be a day of reckless joy as we are scrambled and whirled, jerked and rocked in rides like the Mad Hatter, the Whip, the Tilt-a-Whirl, and Comet Junior. The cotton candy will purple our mouths and fingers; the popcorn in red striped bags will disappear in seconds while we wait in line for the bumper cars. Best of all, Daddy Don will tease and be in good spirits and we will feel like a family at Glen Echo Park. For a few carefree hours I will forget I am overweight and a loud mouth and troublemaker, and it

will feel good to lean back in the Ferris wheel's floating car
and close my eyes riding down the long wave of wind with
all my fears suspended.

True and Perfect Gentleness

For years we'd planned for the morning Everett Hamm's green station wagon would pull up alongside the curb in front of our house after Daddy had gone to work. Until that day, our secret conferences had kept me going, gatherings held in the aftermath of some fearsome family storm when our mother would hold us close and whisper, "It won't be much longer." How else for her to manage the deep hurts but to promise escape while holding, as the words soaked in, her daughter's hands?

In the gray January light we took multiple trips from the house to the car carrying our things. After a couple of hours we crowded in—books, clothes, ironing board, pillows, birdcage—and drove off to our new life with racing hearts in the groaning car. That night, sitting alone on the bottom bunk of Lanelle Hamm's bed, I found myself thinking of Ninth Street North, of Daddy coming home at 5:30 to the dark house, the kitchen. I saw him walking up the stairs calling our names, entering his bedroom, finding the note. The thought made me cry—how was I to know how much freedom hurt? I couldn't get it out of my mind, not even in the joy of moving into a new house a hundred years old, not as we hung our clothes in the delicious mustiness of unfamiliar closets, as we discovered new surfaces for our

belongings and marvelled at the huge antique grate in the living room floor where we would camp all winter for warmth, sleeping on borrowed cots. I couldn't stop thinking of the torn man my father moving in shadows in our house back home, even as I rejoiced to uncringe in all the rooms.

Our flight ended half a year later with Daddy tracking us down after questioning neighbors who'd seen us leave. He came to our town and met Mom at a restaurant. At twelve, I was too young to understand how a man's need can perfectly match a woman's weakness, but what I did know is that once again—for this was the third time our mother had left our step-father—we were leaving a dream to return to my real home with the walls Daddy had painted gray to hide our fingerprints.

From childhood I got the idea that my yearnings were to be struck down, that there is a current stronger than I pulling me away from where I would go. It reminded me of the time I got caught in the undertow at the beach and was wrenched from my mother's arms by a wave the size of a house and nearly drowned. That's what it was like going back to my step-father, to the old inescapable dread of severity and violence.

But now I am a woman and must try to speak like a woman. I glimpse that my ways are not chance but circumscribed. My longings I sometimes taste as the bread of Presence. When my mother soothed me with plans of a better life, she was in truth speaking of heaven. Her hands holding mine were as the hands of Christ. And I was given to see that my step-father, even as he ranted and swore, was telling his loneliness. This vision saved me, I believe, from a certain crippling of spirit in the same way that the words

of a hymn recently helped me see more clearly the character
of my true Father:

> Thou hast the true and perfect gentleness
> No harshness hast Thou, and no bitterness.
> Make us to taste the sweet grace found in thee
> and ever stay in thy unity.

\mathscr{S}tudio

The jazz hugs me. Rich woody sounds invite me in. Drawings of jazzmen smile from the walls: Stuff Smith, Buddy Tate, Coleman Hawkins, Louis Armstrong. And women: Ella Fitzgerald, Nancy Wilson. Many of these famous people are your friends.

Sit down, you say. I am honored. To relish your jazz is to love you. I stomp the Savoy.

At the other end of the room is your studio with its furniture fixed from my childhood: the elbow lamp with its red and black on and off buttons, the drawing table with a perennial cartoon in progress, the antique green cabinet with your art things. I close my eyes and feel the musty cool of another studio, the jazzroom in Virginia which was our basement. Here I catch the whiff of charred pipe tobacco in an ashtray as I venture near your workplace. I am forbidden to touch but at least I can look at perfect order. On the cabinet sits a murky glass of water, eraser crumbs, brushes in a jar, a scratch pad streaked with black and grey. Inside the cabinet doors is a roll of masking tape and a jar of rubber cement which neither I nor my sisters could resist opening so that we might paint the palms of our hands. The mucousy slime became a quick skin we peeled off clean. The magic was worth risking your wrath.

But this is Texas, land of your beginnings. And Texas you've been painting feverishly—scrub oaks and lakes and empty plains—as if to release bottled up pain. I know now it is pain I saw in your eyes all the years of my growing up, the loneliness of a man who could not love children. Step-father, daughter. We nod to Joe Turner's wailing.

\mathscr{R}ainbow

Your package came today in the rain: brightly-colored clothes for the children and me. It was a good sign. Even the musty odor of cigarettes that always seasons your parcels was a comfort, bringing you into the room as we pulled out a rainbow of shirts and shorts.

We'd never given death much thought. Then it came plundering all thought. How can an ordinary scene be so altered, with you pouring orange juice and Dad tying his shoe to him swimming on the floor and you howling? How can it be that he is now but a handful of ash, my father of reddish-gray hair and nervous eyes who used to scare me so? How can I accept that the few, awkward steps I'd lately taken toward knowing him were now frozen, that being a step-daughter means never reaching the top of the stairs?

After his heart attack, Dad seemed to be getting along well enough until he had another massive one in the hospital which plunged him into a coma. The whole fourteen days I could barely eat or sleep. I'd never been in the house where I found myself living. Noise, meals, shower, clocks, TV carried on, but bloodlessly, under a metallic light. I bought some onion plants on a cold March day and went into the unknown yard to plant them. The soil was the

only thing I recognized this day my father kept sleeping. I dug holes with a spoon, and the dirt on my hands reattached me to the world. I put the onions in their graves and tamped down the dirt.

On April 9 Daddy died. A few days ago I dreamed he was walking along a path in the woods with a friend beside him. They were laughing and talking together and for the rest of the day I felt better. Trying on clothes today also helps, despite the steady rain.

Gentle Presence

My sister Leslie and I are near-twins, born a year and a day apart. She's older but I'm more aggressive, which cancelled her advantage, making us equals. I came into a world I fancied to be a stage, and with my sister, God supplied the audience. In the kitchen I told stories while she washed the dishes I was supposed to be drying. Instead I was pacing the floor throwing my towel into the air which somehow helped me think better while the dishes mounted in the rack and the room became a castle or a clockshop. Sometimes I'd wake her up late at night and invite her into the bathroom to listen to my new poem (we dared not wake up Robyn who most certainly was not an approving audience). Incredibly, she'd listen and admire my words and their meanings. One poem, "Hand in Hand," I wrote to her as an affirmation of how we could survive "dark jungles of fear and hate" by chaining together with love our separate worlds. It had little artistic merit, but Leslie liked it, and writing it cheered me up a bit about my home life.

Sometimes Leslie would agree to act in my fantasies, as the time we played teenagers, borrowing our mother's bras and stuffing them with toilet paper, wearing our hair in pony tails, painting on red lipstick, then swinging down

the sidewalk past Terry Glakas' house thinking he wouldn't recognize us.

But really, she was the witty one, the smart one, just quiet about it. All those years she let me shine but I was brass; she was moonlight. She still comes up with those wry little comments that bare the bones of a situation and you wonder that you didn't see it before. When we were growing up, her silence was a threat to our step-father. "Still water runs deep," he'd say, and his resentment eventually crippled them both.

In her senior year of high school she ran off with a rebel on a Harley, had four children and many sorrows before moving to the top of a ridge where she made peace with God and herself, and lives alone among trees and Carolina wrens. People with deep hurts often come to her for help, feeling safe in her presence. For me she is a field without a fence, inviting me to leap when others would have me sit.

Glamour Girl

My mother, my best friend, is seventy. How can it be? When I was thirteen she mentioned she might be getting old. Inconceivable! My mother, Ingrid Bergman. A Hollywood producer once offered her a job in the movies. At the office where she worked in Washington, fellow employees used to say they had their own Grace Kelly at the desk. She was classy—long legs, high heels, stylish dresses, queen's bearing. Style was something she struck like a vein of gold when she left Alabama at 18 to work for the FBI determined to shake off every trace of a farm girl's way.

As a child I loved to watch the rituals of her grooming. After washing her hair, she would sit in the sun and comb it, waist-long auburn hair that turned to jewels in the light. Later, she would sweep it up in a French twist for an evening out while I sat on her bed hoping she would ask me to brush her suede high heels or fasten the clasp on her bracelet.

Each detail held me: the magical sinking of hairpins she used to restrain her river of hair, then the Fawn Beige make-up she worked into her skin. She sketched her eyebrows with a black pencil and wrote her lips Luscious Red. Behind her ears and in the hollow of her breastbone she hid

drops of Arpege like coins, which gave her room an air of faint sweetness I secretly breathed when I would sneak in to visit the treasures in her top drawer—blue rhinestone necklace and earrings, strings of pop beads and pearls, a Peruvian bracelet of silver llamas, a wooden Swiss music box with a sliding glass panel over the clockwork which played three Old World tunes and was a gift to her from my natural father.

After selecting earrings and necklace, Mommy would open the second drawer to draw out silky pools of blackness and smoke stockings. Then she'd go to the closet and riffle through the deck of clothes until she found her favorite cocktail dress, a little shadowy thing that slid over her curves like water. She grabbed her clutch handbag, kissed her girls goodbye and went off with Daddy to the waterfront for jazz leaving us to our pot pies and babysitter.

My mother is still Grace Kelly but with loose clothes and flat shoes. When she comes to visit we hit the outlet mall and bookstore but mostly we like to talk. A country girl at heart, she'll pull up weeds in my flower garden and talk me into buying pork rinds. What amazes me about her now is that she's weathered two bad marriages and several painful deaths but will still tell me or anyone who's hurting, "Everything's going to be alright." And I believe her, even when I look over and see she's fallen asleep in the chair, and I wonder at the weight of her sleep.

\mathscr{I}rene

The door to our basement led to jazz: to Stuff Smith's barrelhouse fiddle or Ella Fitzgerald's mellow ballads. The kitchen door led to cheese and macaroni. The front door opened to Ninth Street with its two-story brick houses like ours built after the war, houses belonging to the Burgesses, Pearsons, Elliotts, Rosens and Eslingers. The street wound up at Wilson Boulevard which carried one eventually into Washington, D.C., where my step-father worked for the Department of Defense. In short, the culture of my childhood was middle-classed, American. We went to public schools, Mt. Olivet Methodist Church, the movies, the Seven-Eleven and the heights of Rosslyn to watch fireworks across Key Bridge in Washington on the Fourth of July. This was the world I knew and it was good.

Irene Getz Neff lived at the other end of the bridge, in the city, and introduced me to worlds of high culture and art. We met at a restaurant where I waitressed one summer and discovered a mutual interest in poetry. It seems her late husband wrote poetry and on his death bed asked his wife to find a publisher. Irene and I kept in touch and she eventually hired me to help her fulfill Harold's wish. Her apartment, a handsome brick building, was on Wisconsin Avenue in Northwest Washington, and from the second

floor where she lived, afforded a grand view of the National Cathedral. On her walls hung paintings of Paris streets. In the window of her immaculate kitchen, little pots held spearmint plants and African violets, with sunshine coming down in a steady rain. Once a week a Spanish girl, Sophia, came to clean. There was a dressmaker called Mrs. Flanders who played the numbers, and a soft-spoken Catholic neighbor named Mary. Talk of books, art, music, theatre floated in the air. On Wisconsin Avenue, one went to the market, not the store, and brought back pastries from an Argentine bakery. For the first time I heard Beethoven's 40th Violin Concerto in G Minor. I tasted pompano. I told my troubles over peppermint ice cream. I accompanied Irene to interviews with famous writers and VIPs in government, meetings arranged by my determined friend who spent years and nearly a fortune trying to publish the *Hometown Skits*. Formerly a public relations specialist, Irene saw to it that some of these influential people benefitted me, her "Suzy," by writing recommendations for graduate school.

I learned that in 1948, Irene, a beautiful but sorrowful young widow, was sent on assignment to Havana (she worked as a writer for the War Department) where she so charmed an artist dining at a nearby table that he gave her an ornate pen and ink drawing of a cathedral now unknown by the outside world, a picture hanging as a gift in my dining room.

In time I was braided into Irene's family: Harry and Harold (at least into his memory), Frieda, Mae, Dorothy, Helen, Mortie and Evie, but mostly into Irene herself, my quick, small, wise, loving Jewish mother who prodded me onto a path I would not have found myself, a possibility path that has led to other countries of the burning mind.

\mathcal{T}he \mathcal{D}rowning

When I was 10, I watched a man drown. I still see him laid out on the pier, a young man in his twenties, entirely blue except for his black swimming trunks and a red gash on his forehead. My sisters and I stood on the bank outside our cabin, sick with fear and regret. After all, we could have helped him—we'd heard him crying from the lake as he fought his way to the surface time and again. We'd planned to throw him the inner tube on our front porch. But Grandmommy said no, he was only bluffing, and our parents in a haze of cocktails and smoke went along with it. Apparently his friends thought he was bluffing, too, as no one at the swimming party tried to help him. I remember green water broken with shadows of firs and crazed red lights and a woman screaming "Sam" over and over. These make a kind of frame for the blue man printed at the center of my memory. Why could no one save him?

All I can think of is another man who cried out, but received no answer. He rose and sank as his lungs filled with blood, but no one stepped forward. I tasted his loneliness yesterday at church during communion. Drinking the wine, I considered that I am asked to love the God who bruised him, the God who let the young man drown. Because of this unreasonable requirement, many people keep

their distance. I often keep mine—it's what you do when your sister dies despite all the prayers of faith, or you read in the paper about four-year-old Annie, scorched, beaten, suffocated by her parents.

But I'm seeing in half-light, I'm barred by time. The resurrection knocked our absurd walls down. A square of folded graveclothes is a window on joy: "He will swallow up death in victory, and the Lord God will wipe away tears from off all faces." But for now there are tears and a man turned blue. And Jesus grieving with us in the blinding dust.

3

STAIRWAY

Reciting Heaven

As you inch in the dark toward my body warmly smelling
of milk and skin, I think of my sister and her strange sleep.
It is a lonely thought, like water falling in a cave. Were it
not for you, my suckling, to fix me to this room in space,
I think I would be lost, drifting after Robyn and the voice
I hear though she doesn't speak.

I know she is not the statue I touched with my hand
(though her blond curls held). She is not resting under a
roof of flowers. Your small breath teaches me to believe all
things and I do, reciting Robyn's heaven in the cave with
you.

\mathcal{R}obyn's \mathcal{P}lants

Cynthia forsythia. Long-limbed, yellow-haired. Incredibly, you were born to your mother without a jot of pain. She called me from the hospital as if calling from a party to announce the advent of nine-pound you. For months afterward she talked about your birth, a fully natural one, and hinted of something spiritual that happened as you breathed your first air.

In this one aspect her dying resembled your birth, for the cancer that began as a seed in her breast and ended as an exhausted weed, carried no pain in its poison. Though heaven drew her with its shining, she fought valiantly to stay in the world, shutting her eyes to bar all distractions—even loved ones standing by—so she could gather her lost strength. You were there when the quiet came, immense and absolute.

Your hair, so soft and light, is her hair, and in your eyes I see her angel.

* * * *

Eric oak. Cut to the heartwood. When you were small I lived in your house on Dawn Cove, a thistle among flowers resisting your mother's gospel as you did when she died. I

argued and smirked and brought beer into the house. You too cringed from the burning. Who is this God whose glory bears down, seizing what is his—a hungry woman, a broken boy? He plants us in a new country of his presence where green leaves grow from our mind and our roots grip eternity.

Puddle Duck

Where was Emily? I looked all over the house. She was no-where. I went to the front porch and there in the driveway in a puddle was Emily naked. My little duckling was sing-ing and splashing as trucks and cars barreled down our rained-on street.

I love the incongruity of children—how they pull up mother's blouse to nurse in public. How they sweetly say, "You're so beautiful," when your hair is awry and you have coffee breath. How they pull on your arm when you are hotly being kissed by their father. How they wear plaids with stripes, take too much food, burp in church, and beat you at checkers. They are still free from the fixed order of things, free to strip and shout and recklessly forgive all who have done them wrong.

Peaceful Haven

The road to the Harper's farm is like a bookmark holding the place of pastures. Driving along with windows down I read the rows of peace: corn and tobacco and rye waver in a green wind. I glimpse a dot of cat in the field fixed on a twitch in the grass. "Good day," I tell a crowd of herefords with solemn eyes, but they ignore me, intent on their cudwork. Rejoice evermore, sing the cloudpeople whose faces shift even as the children in the backseat name them: George Washington, Mickey Mouse.

Now we come to the house at the end of the road with its white columned porch, a perfect stage for acting on any old lazy whim, from scratching a dog's ear to staring at the fence. Ariel, a tan girl with braids thick as vines, stands on the lawn watching us, surrounded by a claptrap of geese. Shirley waits at the door for us to come in, Shirley my friend of good humor and heart, maker of bread, keeper of quilts and quiet. We sit at the kitchen table and talk, and I am calmed by her steady brown eyes and neat rows of jars. I often think of how she helped me labor with Emily, all night consoling and guiding through mazes of pain until the child came and joy climbed up my heart like honeysuckle. I think of her sharing the chill of days when my sister was dying of cancer, how her eyes warmed and held

me and we could hear the children laughing in their inno-
cence upstairs.

Now Rod comes in for lunch, a tall, straight, big-voiced
man with a prophet's beard. He washes his hands that have
cut and planed wood all morning to make cabinets that
gleam with the topography of their grain. He and Shirley
met at a Christian commune back in the seventies. Rod
says he was too dense to realize he was in love, but Shirley
knew he was a man sent from God, and they married, hip-
pie-style, the best of friends. As she fills him in on news of
the house and loads his plate with rice and chicken, I per-
ceive the deep lustrous grain of their love. There are four
children between them and I think there would be more,
but Shirley has an inner-ear disorder—a briar of nerves
that throws her off balance making her sway like water.

"Bless this food, dear Lord," Rod prays. In this house
blessing shines like the leaves of the philodendron or yel-
low butter or the eyes of the cat at an angle. I'll stay an-
other hour or two, then go back down the gravel road that
enters the clamorous highway.

\mathscr{F}leeting \mathscr{E}nchantments

(for Katy on her 15th birthday)

Passing by the stairs I was startled to hear other-worldly
singing, high and crystalline, aimed somewhere past birds
in flight. Is there a radio on? I asked, ascending. But no, it
was my girl Katy, singing with this new, unheard of voice
given her once when my back was turned, given by the same
Hand that secretly poured upon her head a pitcher of gold
so that overnight her pale, unruly ponytail was changed
into a sunstorm. And where, I asked myself as I glimpsed
her standing at the edge of the pool, did she get those swan-
like curves, those gazellean legs? Even her handwriting has
been charmed: the careful schoolbook letters are suddenly
leaping into waves across the page, and I blink at loops never
seen, swooping down like cormorants below surfaces of
thought. She is a watercolor, running in a blur of wheat
and ivory toward an edge I cannot see.

The Gift

If someday you should be found missing, I would not want to look upon the hat you gave me, the funny denim pull-down hat with the rose, and not have worn it. As it is, the hat will hurt because you bought it for me, a whim of love, and because I have worn it to love you back. Such exchanges between daughter and mother—deep calling unto deep—make grooves that are called scars when someone dies.

The cut is made when I pause from my papers to behold Emily doing a dance for me, her face solemn as she spins and leaps under the spell of grace she has conjured for herself. No matter if she misses steps or fails to fill with movement an awkward space in her invisible music. What counts is that I take the gift despite all risks: the destitution that would devour me if I were to lose my dancer.

Not to watch the ballet or wear the hat is a cold and withering sin.

Backyard Mystery

In my back yard, rooted next to the house and drawing birds the world over, is a holly tree. I wonder at those who eat the berries:

> purple finch, goldfinch, blue jay, waxwing,
> mockingbird, cardinal, chickadee, wren.

Once a commotion called me to the dining room window to see a huge bird that had somehow stumbled into the tree, a bird with the eerie screech of a hawk. How does a hawk wind up on busy Pennsylvania Avenue? And what was a hoot owl doing in this neck of the alley behind my house one summer evening, not once but more than once? Moles have dug doorways right under the nose of the children's swingset. A big pileated woodpecker spent three whole days banging away on a corner cherry tree. A ghostly possum weaseled through Claire Evelyn's fence into my yard. Who sends these things my way? Who charges the town with wilderness that burns in an owl's gold eye?

Why I Stuff My Pockets

It is rude, I own, to listen to a Carolina wren fluting in a tangle of bayberry trees instead of to you, my son, and your birthday wish list. Forgive me that I want to forsake you for acres of shore, for bat ray plates and shark's teeth, for sand dollars and sea glass. I want sky and no talking, sand without tracks, a vacant rock.

It is of course because of you I want to drink the world. What would I care for the rufous-sided towhee if I had no boy to yank my arm? Why would I stuff my pockets full of olive shells if you did not cry out, crazy from a nightmare, for me to come? Or did not kiss me goodbye fourteen times as I go out the door? One of your freckles weighs more than a star. One smile surpasses the sea.

*B*lackberries

I was washing blackberries in the sink, proud of my stash, and was still picturing myself by the road picking pockets of briars. Then my father-in-law began to tell of a Castlewood woman who also went for blackberries, leaving her children in the car. "Be right back," she told them, swinging her bucket. A while later a policeman drove by and saw the children crying. "Mama's gone over there," they said. Off he went to find her in a wide field of weeds, the sun blazing. He saw no woman at all, only wilderness. He hurried to the edge of the field, to the blackberries, and there he saw her lying face-up in the grass with copperheads crossing her body and her eyes empty as the sky. Twenty years later I was making a cobbler of the treacherous blackberries, which we ate—the children, the father, the grandfather and I— thinking of the other mother and the vast field of harm from which we have been kept summer after summer.

*F*alls

A staccato of rain announces me to the creek. I slip my way down a skin of leaves to inspect the waters of Roaring Falls. I like a loud place in the woods the way I like to yodel in my house. Sometimes I burst like milkweed and out come the crazed falsettos while the children gather to gawk. The other side of yodels is sobs. In church the Heaviness will descend, and I will be carried downriver breaking on a word, losing my mind in the Roaring Falls of grief. But now I am simply a guest standing on a mossy stone, safe from all devouring.

Heaping

Today I am thinking of heaps—heaps of leaves strewn into the street by last night's rain, heaps of meat and beans and pies on Thanksgiving plates, heaps of kleenexes from two colds in the house. "Heaps of love" is the way my mother often signs her letters. *Heaps* is the word, the jolly, good-hearted word used in the Bible story I told my Sunday school class: silver and gold in heaps, animal skins, acacia boards, and fine cloth—how recklessly those Israelites heaped for the building of the tabernacle. Heap is what a poor widow did with her two cents, making Jesus glad. Sin was heaped on him but He did not throw it off. Oh, it was heavy, but it did not break his back.

*E*mily's *P*rayer

Emily prayed that God would protect everyone and make their bodies turn into green leaves. This is a good prayer. If our bodies were green leaves (instead of burrs and thistles), we wouldn't hurt one another. She must have had me in mind, old she-wolf with a mask of loving mother. So many fairy tales hint of brooding darkness. I confess I have wanted to eat up all my babies whom I gleefully fattened at the breast. I admit metamorphosing at the drop of a glass into a shrieking hag. And, sin of sins, I own I have thrown away priceless drawings by three-year-olds.

No wonder she asks for leaves. Together we would dance in wind and spend our days eating light; ours would be the green of frogs and inchworms. As I kissed her, I thought I should like to climb into her tree-mind safe from my own dark self and grow sleepy hearing the faint birds settling in the hemlocks purple and far away.

Mourning Into Dancing

This is the third spring that mourning doves have nested in the ivy on the sill of my pantry window. Each time I reach for soup I see a dark, wet eye regarding me. Her mate the woodwind keeps watch in the nearby holly tree, his throat rolling the same glum notes over and over as she sits on her somber eggs. I sing to her, too, my old standby for doves, "The Indian Lullaby."

The dining room window gives an even better view of the nest. After a couple of weeks the female will start picking away, and then there will be these two extra heads and a lot of shifting around and the father on whistling wings coming to spell her. It isn't much of an exaggeration to say that a day or so later the young will be nearly grown and crowding with their pear-shaped mother into the saucer. Shortly afterward comes the moment I see the nest is empty, and there on a holly branch sit the four, docile as cows.

Drab as they are, the mourning doves do something extraordinary. The young perform a sort of dance with their wings, draping them over their parents who in turn give them regurgitated food. It seems sacramental, this adoring and feeding that overwhelms native sorrow and arrests me in the act of dusting chairs.

Grayson Highlands

This is a place full of eyes and giants' bones, of mists and moss and drowning silence. I drink the wind as we go along, as the children split off toward a spiny ridge. Everything here is either grounded or vanishing. In the shadows of boulders stand wild ponies with lowered heads, heavy as time. From hawthorne thickets juncos cast a few silvery coins of sound into the vast quiet. Everywhere I turn are blueberry bushes and blackberry vines loaded with short-lived fruit. Al appears with a camera to freeze me in the act of eating. We both see that "All the road to heaven is heaven," as St. Teresa of Avila said. He photographs, I write the road.

\mathscr{S}and \mathscr{D}ollar

I've left my family far behind. My feet have their own life, taking me away and away. The naked beach curves like a woman's body. Watery hands clasp and free my ankles. Sandpipers look in mirrors left by the last wave. In the distance, sky and sand are one and I am going there, drawn by the vastness of Being. I exalt in immensity but there's also this loneliness, Lord, like an ache in my bones. Please give me a sign. I know it's outrageous to ask, but how about a sand dollar? You know how much I like them.

I chide myself for such a prayer as this. The Word tells me God is everywhere at once but here everywhere is swallowed up in roaring. Against the sheen of the infinite shore, I see the motions of my life carrying but the weight of a ghost crab. I've seen no sand dollars on this beach and barely any shells, but look, here it is at my feet—a flower floated down from heaven. I pick it up and study the star at the center drawn like a hieroglyph from another world. *Yes, I'm with you*, says the sign. I turn back the way I came, awed by the wealth in my hand.

The Brickyard

Al and I were in Williamsburg celebrating our nineteenth anniversary. We stopped by the brickyard, which took shape in my mind as a metaphor for our marriage. Some boys were trudging around barefoot in the mud pit, working the clay, softening it, the way habits and customs go into the common pit to be squeezed and trampled. My sense of humor (Irish, I'm told) exalts in far-fetched stories being passed off for truth. But this had to go, right at the start. Al wasn't amused at my telling him I'd been a ping-pong champion in high school, then finding out when we began our first game (he leaning forward, poised for serious play) that my idea of hitting the ball was to zig-zag it off the far wall before losing it under a sagging, overstuffed sofa.

But neither did he get by with one of his outrageous quirks—namely a weakness for hitchhikers. Not long after we married I had to dig my heels in and tread upon his practice of stopping for the hitchhiker with the stringiest hair and glassiest eyes, the one with the strongest smell and rattiest tank top. He was, Al figured, a likely candidate for the Gospel. I figured the candidate would reach any minute into that brown bag hitchhikers always carry to pull out a gun and shoot us.

These were the big oddities, not too hard to quash. It's the small subtle particles in the clay—sarcasm, criticism, nagging, complaining—that take the most time to pick out. After the clay is stomped, the bricklayer pulls off a sizeable slab to knead on a board like bread dough. Another laborer takes the mass and works through it to locate and remove any hard lumps or pebbles. So it is that through love's kneading, the small impurities arise, and the mingling of flesh exposes flecks of malice. The purified clay goes into a wooden mold and is flattened and fitted with a wooden tool called a striker. Then the brick is taken to a sandy drying area, loosened from the mold, covered, and stored until firing. In Christian marriage, the mold is Jesus; the flattening and fitting is the clash of passions, the death of willful dreams. Over and over, year by year, the relationship tears and mends. Grief is the striker, shaving off the overlay of temporal longings that deaden our hunger for God. But the final smoothness and solidity of form make a fine brick for a building.

In Williamsburg the bricks lie covered all summer until October when they are loaded into the furnace. The firing takes six days. About this time the brickmaker starts looking for a yellow glow, the sign of readiness. Too white a heat means an unstable brick.

Similarly, at times my partnership with Al seems dormant—long seasons of dullness and distance. Then comes the trial—the casting into flames—Emily is run over by a car, Al's father draws his last breath as we look on. The pain is fierce. The whole inner life glows like a savage sun. The Brickmaker watches and waits. Now it is time. He plucks us out to cool and harden. Come spring the new house will be built, not of clay but love refined by the rigors of the craft.

Lunches

Years of lunches I've made for you my husband, years of white and wheat and pumpernickel bread, of pickles slick as fish and slabs of bologna, ham, and salami with seven eyes. And leftover lasagna, tuna casserole, Mexican Delight, and vegetable soup that leaked out of the plastic container all over your magazine more than once. I've packed grocery sacks to hold the many foods I fix to take you through twelve hours of sweat and labor, apple pie to cheer you when the men are filling the cafeteria with blue smoke and laughing at the size of your lunch and referring to each other with names like Big Foot and Duckie, Smiley, Fox, and Hat.

Have I thanked you for breathing aluminum motes all these years, for bagging up millions of can ends in the middle of a thousand nights? You could be sculpting a water lens of wood or soldering metal strips for a wind chime. But instead your feet are aching inside heavy black steel-toes, and your hearing's slowly ebbing from the pounding of machines. Still you punch in at six or six to fix your hands to their monotony. You'll be retiring one day not too far from now, so whatever you do, don't stop dreaming. Keep the poemshapes reeling in your mind.

Chick Magnet

One morning not long ago Stephen stumbled downstairs, grabbed a cereal bowl and greeted me with "Hey." I did not know the voice. Later I picked up the phone to make a call, and the man's voice was talking to a soft girl's voice. This too was amazing. Stephen had always hated girls and kissing scenes in movies. Yet recently a kid had called him a "chick magnet." Imagine that. Actually, I'm not surprised. He doesn't flirt or flex his muscles. He says funny things and deep things and plays the "Turkish March" so passionately the keys smolder.

Tonight, talking with him in the kitchen while fixing supper, I notice his legs are long and hairy and that he's growing sideburns. When he grins at me, I read full equality. What we have now from this height is toleration and amusement toward his poor old mother who worries too much about what the boy will be and how he'll fare. Will he stay true? Will he stay tender? Will he be happy in the hard years ahead? I wish I could see those far-off years as I saw who he would be before he was:

Sprout
(for my unborn son)

Little fish
wishbone
princelet
sprout:
I see you swimming
with all your might
in a drop of nectar light,
your wee heart blinking for joy,
glands humming,
the brain busy and pleased,
all wired up
for whistling.

Aladdin's Lamp

The white elephant of birds has got to be the nighthawk, known in these parts as the bullbat. You think it's some sort of electric cable gone haywire, this buzzer that shows up around the time you notice the first lightning bug, but it's really the nighthawk marking the sky. Hawk is mostly a misnomer—the bullbat is classified as a goatsucker, a kind of whippoorwill with a sore throat. Its flight pattern occurs in fits and starts. High in the darkening sky the bullbat flies in spasms, buzzing all the while. But suddenly comes an indigo silence and swooping. It's a hawk riding the drafts. But only for an instant. The bullbat is back, bat wings shivering.

I saw one up close once on Edgemont Avenue. We were driving along one summer afternoon and I happened to notice a strange squat form on the roof of a roadside shop. I asked Al to pull over and back up so I could see better. It was a nighthawk, fast asleep, an Aladdin's lamp waiting for dusk so as to fill the sky with volts of praise to the Maker of all creatures weird and wondrous.

Pokeweed, Sneezeweed, and Butterbeans

After nearly 20 years I still can't get over the plants in my yard: first the mystery of them; second, possession of what can't be owned. To get to the back yard I can either go along the steep side next to Hattie's house and see lilies of the valley by the fence which bloom in April with the fragrance of Christ, or I can go down the basement steps and pass by the holly tree and the bearded side of the house where finches and doves nest (at the end of every summer I vow to pull the ivy down but can't quite bring myself to do it). Here the ground is covered with prickly holly leaves which can be suffered if I walk on the outside edges of my feet in the event I forgot to put on shoes. Then come violets and a pear tree that used to put out huge, hard fruit but now manages only marbles. Its neighbor the apple tree wears a wren house like a locket.

Along Hattie's fence poison ivy gets me every time because I like to feel dirt when I garden and have all along refused to wear gloves. This spring I had to have my wedding ring cut off. Like Toad I'm forced to reform; I'm bowing to gloves.

In the far corner of the yard near the alley is a for-
sythia bush I planted in honor of my grandmother who
died one March evening only minutes before we arrived to
see her. The forsythia was ablaze the day we left her house
forever, the house of butterbeans and strong tea and a "Bloom
Where You're Planted" sunflower plaque I now have hang-
ing in my kitchen.

At the opposite side of the yard along Claire Evelyn's
fence is the old hamster burial ground. Here, rose of sharon
competes with the intractable bamboo I tried to drown out
with fescue. Virginia creeper, honeysuckle and bittersweet
braid the rusty ironwork of her fence. The herb garden is a
riotous shape. Lemon mint and peppermint overflow the
banks of brick, and thyme is swallowed up in sage. I visit
my herbs almost every day, but clearly plants aren't my life.
Sometimes I just don't make it to the back. Sure enough
it's during one of those absences that a certain Undesirable
(you know who you are) sneaks into my garden, a criminal
type with purple blood in his veins and a slick torso that
beds down with the decent plants and grows promiscu-
ously so that by the time I show up, the thing's already
three feet high and flashing its broad leaves. Though I kick
and stomp and strike with whatever stick is at hand, the
monster pokeweed is back in a week—a couple of S-curves
in the spine, to be sure, and minus half its leaves—but in-
sidiously back, pumped up, in thick with the painted dai-
sies.

There are stories of a crippled peach tree, of long-gone
orange lanterns, failed forget-me-nots, and popweed with
seeds like grasshoppers. In the fall asters catch my eye, and
Asiatic dayflowers, goldenrod and blood-berries on the dog-

wood. I am wealthy in my plants, in my purple-headed sneeze-weed. I would be as the Japanese of whom Van Gogh said, "These . . . live in nature as though they themselves were flowers."

When Snow Sifts Down Like Fairy Dust

Emily said she had a hunger. But she was sad she couldn't go to the beautiful worlds she imagined. She said she knows the reason—that the worlds she sees in her mind will only be known in heaven. She said music wakes her to this hunger.

She was eight years old when she told this to me. I wrote it down in my journal. The drawers in our house are full of Emily's poems and stories. She writes things like, "The sun is a cannon shooting light into our world," and "Why does the snow sift down like fairy dust?" I hear her listening to Mozart in her room and know there will be a poem. Sometimes when she is supposed to be in bed I will see her writing in her notebook. "Please let me finish my story." I always let her finish. Beautiful worlds from heaven must be allowed to come down.

The Outpouring

Black clouds cover the city,
sleet and hail fall in torrents.
Mud and straw blanket the ground.
Running sounds of feet and screams

coming from people in a crowd.
A flash of lightning and an earthquake.
The moon covered by heaviness
of the churning sky.
Over and over , the word "forsaken"
drowns in moaning sounds.
What could this be?
The tears that drench the people's eyes.
The blood and water, a battle of belief.
Darkness and sorrow.
A pouring out of heart and soul
to show us who we really are.
The cross across our backs,
the weight removed at that one phrase,
"It is finished."
He took our pain and made it His
that night, the crucifixion.

(Emily, after disappearing into her room for a long while,
reappeared with this poem, written at age eleven.)

The Fifth Season

It's been a cold, wet spring, not enough sun for planting. At J&R's Produce it was slim pickings—most of their plants were spotted and yellowing. I went ahead and bought a few tomato and cucumber plants hoping it would turn hot soon. The peonies in my yard droop like drowned cats. Emily's pool sits in the basement corner crumpled and useless. Shirley lies in her bed for the second straight year.

The doctors call it a vestibular disorder. Vestibule: a passage between the outer door and the interior of a building. She's trapped in the hall, so to speak. Close by is her kitchen with her grain mill and bread board but no bread, and a freezer that used to be stuffed with garden vegetables but now holds only a few casseroles brought by church people. There's a window by the sink where she used to stand looking out on the herb garden and fields. But what are purple coneflowers to her now that her life has narrowed to this one room where day and night turn over and over like a heavy wheel until all the light is gray?

Her husband and children float in and out to sit on her bed, help her up to use the portapot, wash the clothes, cook, turn on a movie. Shirley told me that not long ago it hit Russell that his mother wouldn't be getting up from bed, maybe not ever. Grim thought for a four-year-old.

Lord, this has been hard for me, to watch my closest
friend languish in a strange season where time yellows and
sags and the heart fights to keep faith. Shirley's trying a
promising new treatment called cranial-sacral therapy, but
the going is slow and her world remains a tilting world.
This morning I read some words teaching me that deeper
reality governs, that my perceptions are often fractured
like broken windows instead of figured like stained glass
where light reveals design.

This is Habakkuk's picture:

> Though the fig tree may not blossom,
> Nor fruit be on the vines;
> Though the labor of the olive may fail,
> And the fields yield no food;
> Though the flock may be cut off from
> the fold,
> And there be no herd in the stalls—
> Yet I will rejoice in the Lord,
> I will joy in the God of my salvation.

The last verse I offer as a prayer of hope for Shirley,
but I pray it for myself, as well, for her suffering, like a
towering mountain, obscures my path:

> The Lord God is my strength;
> He will make my feet like deer's feet,
> And he will make me to walk on my high hills.

*P*airing

One thing I notice in the mad clutter of our house are pairs of our belongings. In the bathroom next to my pink bar of Dove is a little pink Barbie soap. In the kitchen on the potholder hook is your smaller version of my red cooking mitten. Once when I unzipped my cosmetic case, there inside was your vinyl case with play lipsticks and Tinkerbell toilet water. This reminds me of how you were once zipped up inside me, a mole tunneling about, making lumps on the terrain of my stomach.

I always thought my life was separate—time enough for you but now I need my own time. Over the years, through the bleeding together of hours and days, through the filling of rooms with people grown taller and more ever-present, my "own" time has dwindled to the size of a watchface whose scratchings are hard for me to read now. Where will you go, you three to whom I've paired myself one by one by one? And your father following you out the door in a rush of parting words he meant to say all along, bewildered at the silence of the house closing in behind?

Where will we go, he and I? Sorting socks today (job never done), I think of Christ coupling with us in chaos, in the rough wind, in the smoldering field of ash where we once lived.

House of Candles

In a few days the street outside our door will be blank. Every driveway will hold its ice-glazed car. The neighbors will be home with all their lights blazing. And so will we be found at home—Al and I, Katy, Stephen, and Emily—lighting candles for the reading of the Gospel. The blinking jewels of our Christmas tree will mark time, treasured time as we listen to the story together and sense the wonder in the house and in the world. The Child is sleeping. He has come such a long way: let him be. His mother, weary and weak, leans against Joseph, strong to shoulder the public shame of being father to a child not his own, yet fully his own.

But what honor there is in shame, for is this not Jesus, son of my heart, whose slippery shape I grasped as he plunged into the dark and foreign air? Is he not Savior, this dreaming boy who has drawn a barnful of adoring shepherds? What have I, a rude carpenter now a father, to teach the Son of God? Mary will tell me how to listen, how to bend like a reed that I might hear the Almighty's words. For it was Mary he chose to overshadow with swirling light. Together we will ask God and he will show us the way. We will ask along the road going home.

Al shuts the book and we sing by candlelight, O night divine. I study the children's faces, like cameos against the

shadows, and wonder myself how I can teach or tell, stumbling about as I do in this poor light so far from heaven. I will ask God and he will show us—the father, the mother, the children—enough of the road on any given day.

About the Author

SUZANNE U. CLARK lives in Bristol, Tennessee, with her husband Al and children Katy, Stephen, and Emily. She is the author of a poetry chapbook, *Weather of the House*, and a non-fiction book, *Blackboard Blackmail*. She has taught literature and writing at King College and teaches classes of the same to homeschooled students. She also conducts workshops on writing and the imagination for teachers and students.

Her poems have appeared in many literary journals such as *Image*, *The Southern Poetry Review*, *Anglican Theological Review*, *Shenandoah*, and *Sow's Ear Poetry Review*. Her poetry has also appeared in the anthologies *In Place* (Appalachian writers) and *Words and Quilts*. She has published poems and essays in *The Writing Room*, a book on the craft of fiction and poetry, and was a resident fellow at the Virginia Center for the Creative Arts. She has an MA from the Johns Hopkins University Writing Seminars.

Suzanne is also a free-lance writer whose feature articles are regularly published in *God's World* and *Power for Living* magazines.

Acknowledgments

Grateful acknowledgment is made to the following publications in which these poems and essays first appeared:

"Sprout" in *Wellspring*.

"Treasure" in *Weather of the House* (used with permission).

"Obstetrics" in the *Sow's Ear Poetry Review*.

"Bamboo" in *God's World Today*.

"Impossible Child" in the *Bias Report*.

I would also like to acknowledge my gratitude to Doug Jones for providing a home for *Sketches* and for his fine assistance throughout.